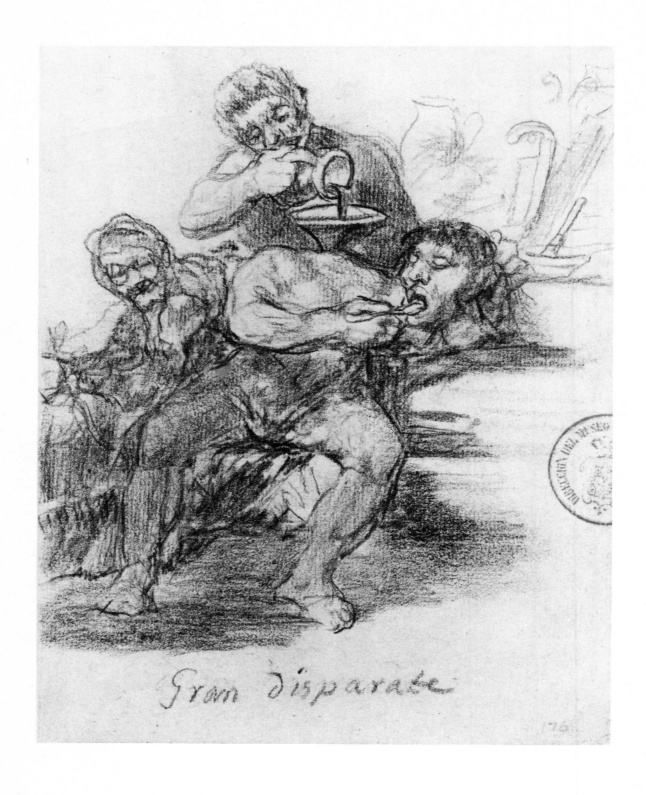

"Great folly." From Album G (see page 44). 1824–8. Charcoal. 192 × 152 mm.

GOYA
DRAWINGS

44 Plates by
FRANCISCO GOYA

Dover Publications, Inc., New York

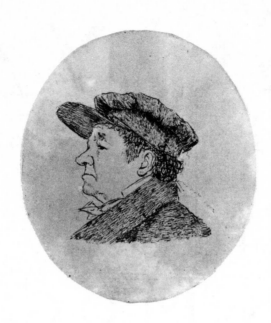

Last self-portrait. 1824. Pen,
sepia ink. 81 × 70 mm.

Published in Canada by General Publishing Company, Ltd., 30 Lesmill Road, Don Mills, Toronto, Ontario.

Published in the United Kingdom by Constable and Company, Ltd., 10 Orange Street, London WC2H 7EG.

Goya Drawings: 44 Plates is a new work, first published by Dover Publications, Inc., in 1986. All of the drawings are reproduced from photographs provided by the Museo del Prado, Madrid, to the staff of which the publisher wishes to express his gratitude.

Manufactured in the United States of America
Dover Publications, Inc., 31 East 2nd Street, Mineola, N.Y. 11501

Library of Congress Cataloging in Publication Data

Goya, Francisco, 1746-1828.
 Goya drawings.

 1. Goya, Francisco, 1746-1828—Catalogs. I. Title.
NC287.G65A4 1986 741.946 85-20597
ISBN 0-486-25062-8 (pbk.)

PUBLISHER'S NOTE

Although Goya (1746–1828) was one of the great masters of painting, only a handful among some 850 surviving drawings are preliminary sketches for canvases (page 42 shows one of these rare items). Most of his drawings are either sketches for print series, whether completed or merely projected, or else part of an ongoing visual diary of his inquiring and sympathetic spirit. Like the best of Goya's prints, the best of his drawings—the most innovative in both technique and style—were not produced until after his fiftieth year. The present selection includes some of the preliminary drawings for each of his major print series (none exist for *The Bulls of Bordeaux*) as well as a number of other outstanding drawings in a wide variety of media. Goya's best-known subject matter will be found here: portraits, scenes of fantasy and horror, bullfighting, witchcraft, the sorrows of war, social satire, prisons and executions, liberalism and anticlericalism.

The sequence is roughly chronological, although dating must often be tentative.[1] Drawings for print series are kept together, and kept in the numerical order of the published prints; drawings originally contained in any given lettered album (although that album may now be dispersed) are also kept together, but not in any numerical order (many of the numbers on the sheets are in Goya's hand, and may refer to planned print series).

The works on pages 6–8 are from two albums (A and B), associated with an Andalusian trip made by the artist in 1796–7, that are immediate precursors, and partial sources, for his work on the *Caprichos*. That turning-point print series, published in 1799 (one of only two series published in Goya's lifetime), is represented here by the preliminary drawings on pages 9–18.

The superb Album C, a sketchbook begun about 1800 and maintained until the artist's departure from Spain in 1824, is the source of the works on pages 20–35.

Album F (pages 36 and 37) contains a number of drawings closely related thematically to the print series *The Disasters of War*, a record of the Peninsular War of 1808–14 and its aftermath, preliminary sketches for which appear on pages 38 and 39.

The bullfight print series *La tauromaquia*, published 1816, is represented by the drawings on pages 40 and 41; the later print series *Los disparates*, by the sketch on page 43.

Goya lived in France, chiefly Bordeaux, for the last four years of his life. Despite his advanced age, he avidly continued to draw real and imaginary subjects, expanding his range of media to charcoal and lithographic crayon. Some of his finest achievements are to be found in Albums G and H and in separate sheets from these years (pages 2, 4 and 44–47).

The captions either translate (within quotation marks) Goya's inscriptions on the drawings or give a brief identification when there is no inscription. The source album or associated print series is then given, followed by the approximate date of the drawing, the medium and the original size (usually the sheet size) in millimeters, height before width (33 of the 44 drawings are reproduced here at actual size). Here and there a further explanation is supplied (within parentheses). Limitations of space made it impossible to include longer discussions of dating and interpretation, or to print the original Spanish wording of the inscription or the titles of the associated prints.[2]

The largest single collection of Goya drawings in the world is that of the Museo del Prado in Madrid. All the drawings in the present volume are from that great collection, and are reproduced from newly prepared museum photographs. These carefully made and unretouched photos, despite the obtrusiveness of the nineteenth-century ownership stamps, give a better idea of the originals than can be found in many earlier publications of Goya drawings, which were characterized by severe cropping, airbrushing and the destruction of the relationship between image, inscription and physical sheet.

[1] The dating adopted here is that established by Pierre Gassier in his indispensable work *Les dessins de Goya: Les Albums* (1973) and *Les dessins de Goya, Tome II* (1975), Office du Livre, Fribourg (Switzerland). The assignment of drawings to albums, the identifications of Albums A–H, the dimensions and many other elements in the present captions have also been taken, with gratitude, from Gassier's volumes.

[2] Goya's major print series are available in excellent reproductions, with full identifications and useful introductions, in the following Dover volumes: *Caprichos*, 22384-1; *Disasters of War*, 21872-4; *Tauromaquia* (with *Bulls of Bordeaux*), 22342-6; *Disparates*, 22319-1.

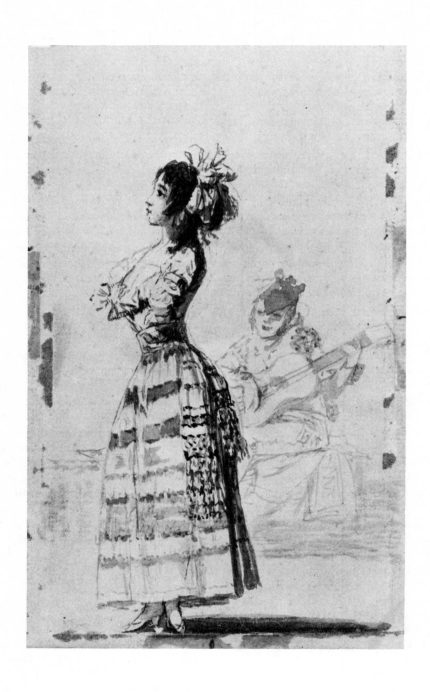

Andalusian dancer and guitarist. From Album A ("small Sanlúcar album").
1796–7. Brush, india ink wash. 170 × 99 mm.

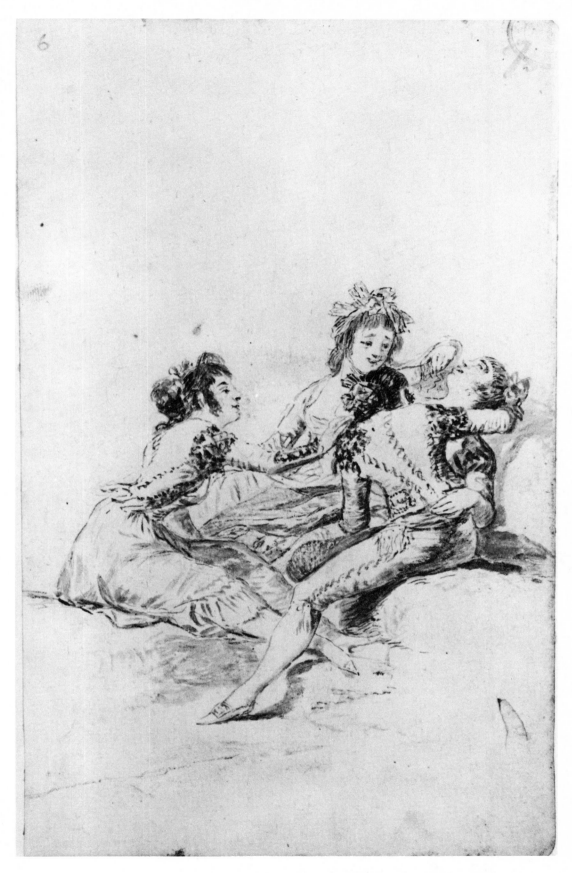

Reviving a woman who has fainted outdoors. From Album B ("large Sanlúcar album," or "Madrid album"). 1796–7. Brush, india ink and bistre. 235 × 144 mm.

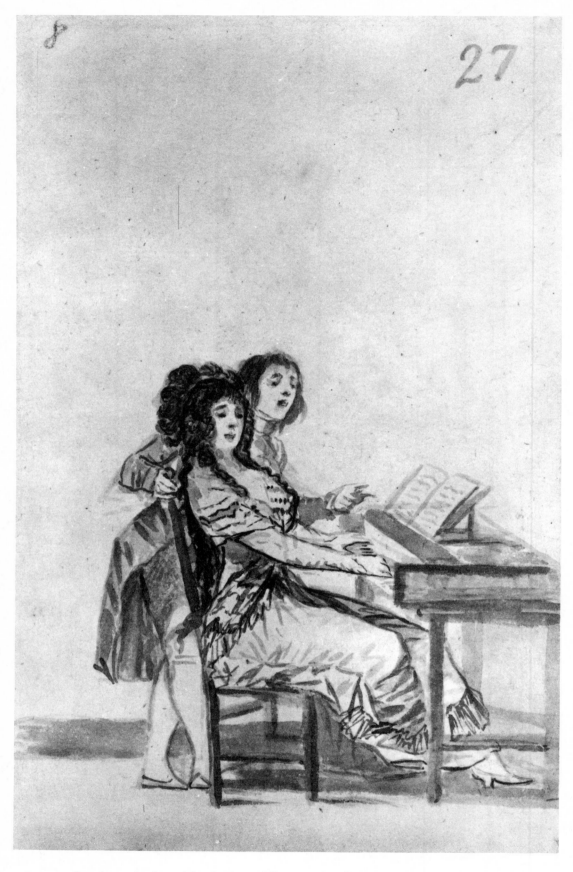

Couple at the harpsichord. From Album B. 1796–7. Brush, india ink wash. 235 × 145 mm. (Probably the Duke and Duchess of Alba.)

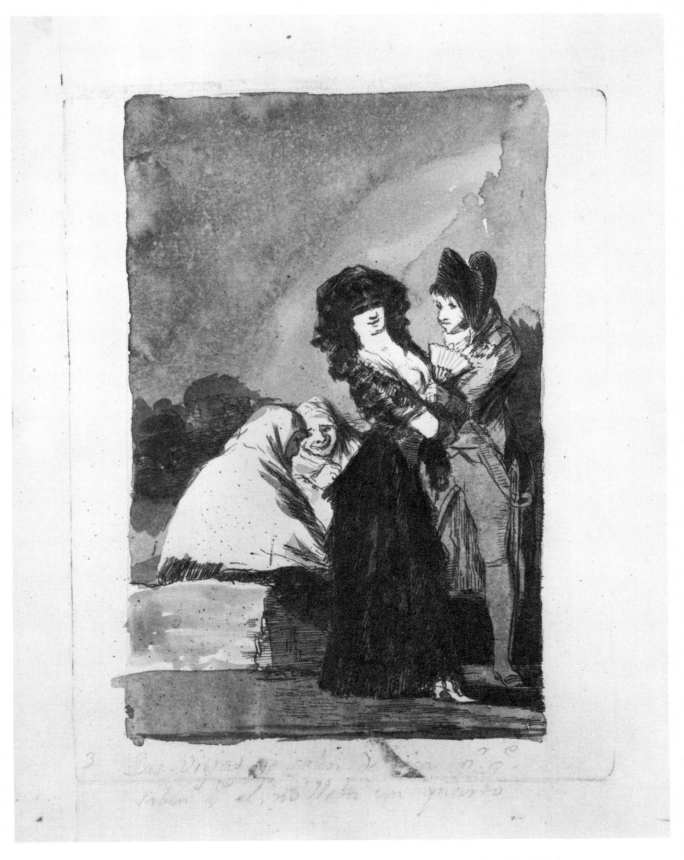

"The old women burst out laughing because they know he's penniless." Preliminary drawing for No. 5 of the print series *Los caprichos* (Caprices), published 1799. 1797–8. Pen, sepia ink, with india ink wash. 245 × 185 mm.

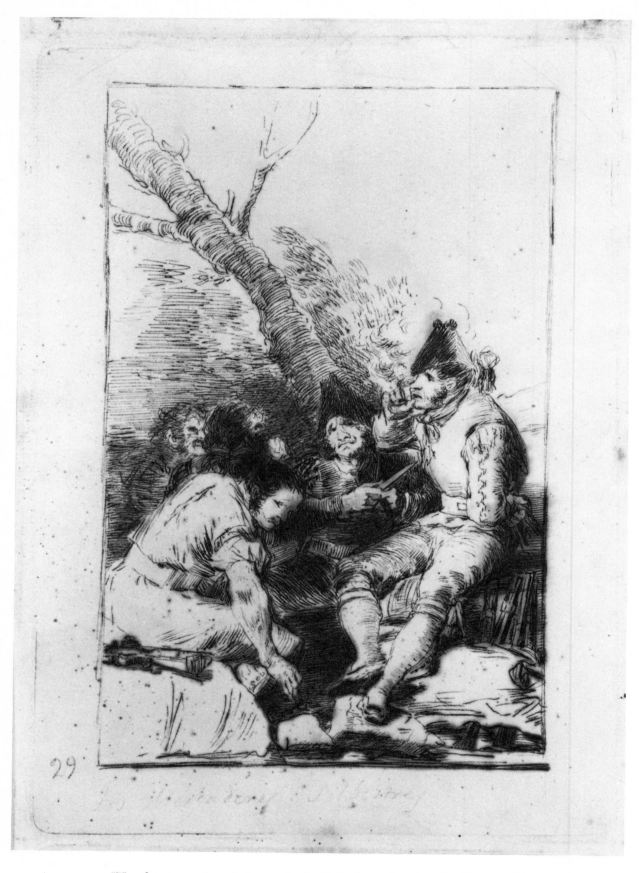

"The forest merchants" [smugglers]. Preliminary drawing for No. 11 of *Los caprichos*. 1797–8. Pen, sepia ink. 233 × 162 mm.

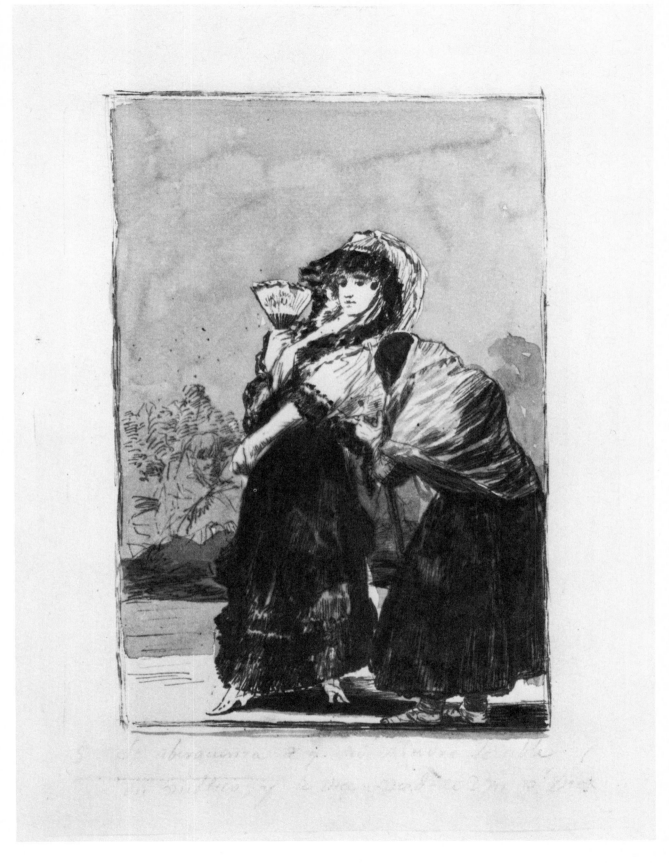

"She is ashamed to have her mother speak to her in public, and says to her, 'Excuse me, please.'" Preliminary drawing for No. 16 of *Los caprichos*. 1797–8. Pen, sepia ink, with india ink wash. 245 × 169 mm.

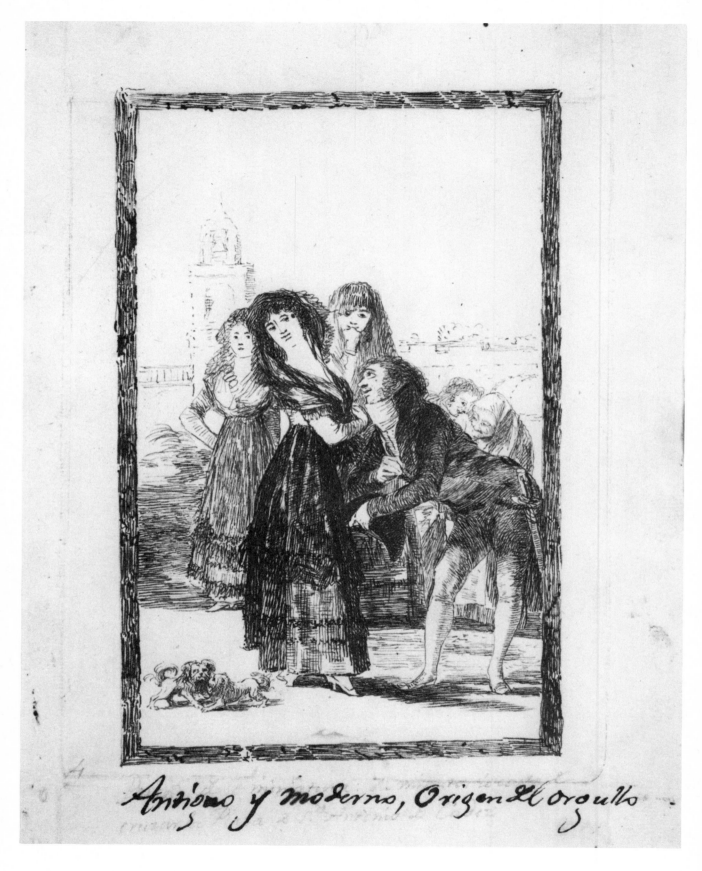

Antiguo y moderno, Origen del orgullo

"Ancient and modern; origin of pride." Preliminary drawing for No. 27 of *Los caprichos*. 1797–8. Pen, sepia ink. 244×185 mm. (The locale is the Plaza San Antonio, Cadiz.)

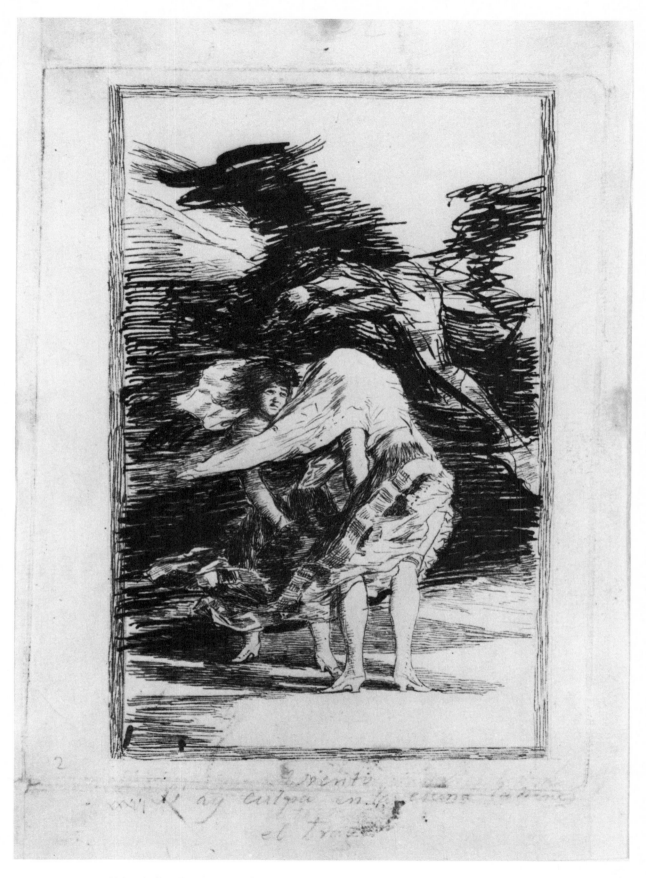

"It's windy. If anything is blameworthy in the scene, it's the dress." Preliminary drawing for No. 36 of *Los caprichos*. 1797–8. Pen, sepia ink. 240 × 165 mm. (Streetwalkers.)

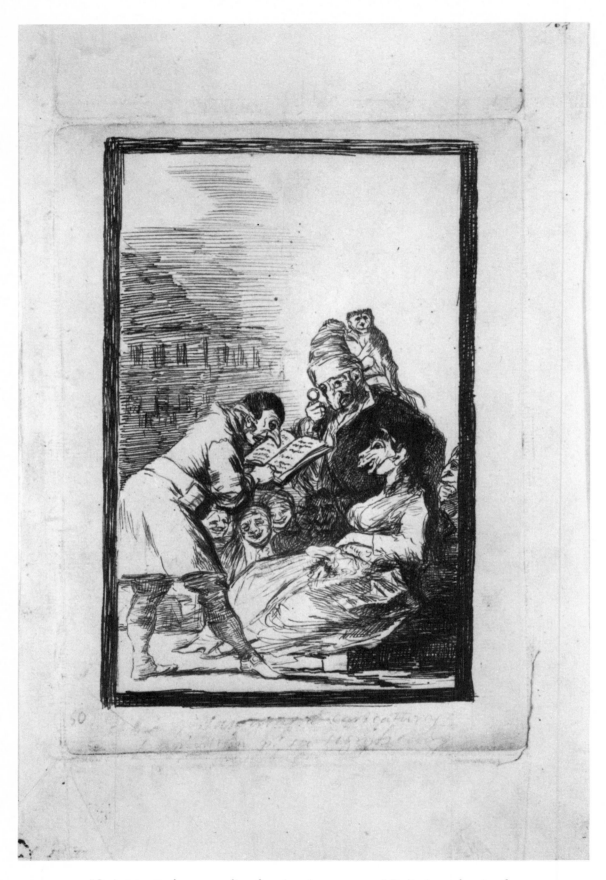

"Caricature masks outstanding for what they represent." Preliminary drawing for No. 57 of *Los caprichos*. 1797–8. Pen, sepia ink, with touches of sanguine (red crayon). 292 × 185 mm. (Pedigree of a prospective bride.)

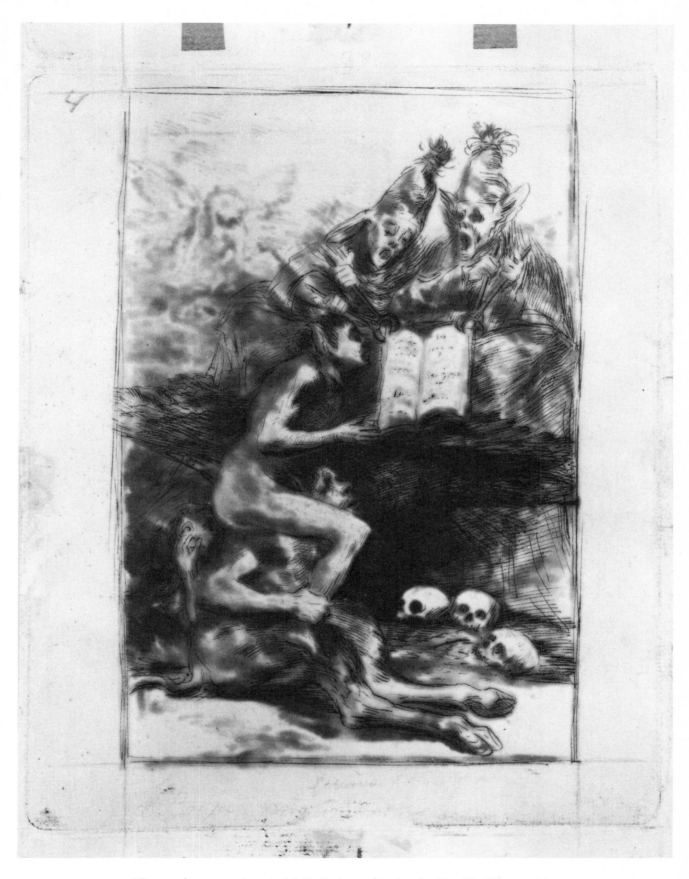

"Dream about a novice witch." Preliminary drawing for No. 70 of *Los caprichos*. 1797–8. Pen, sepia ink. 237 × 179 mm.

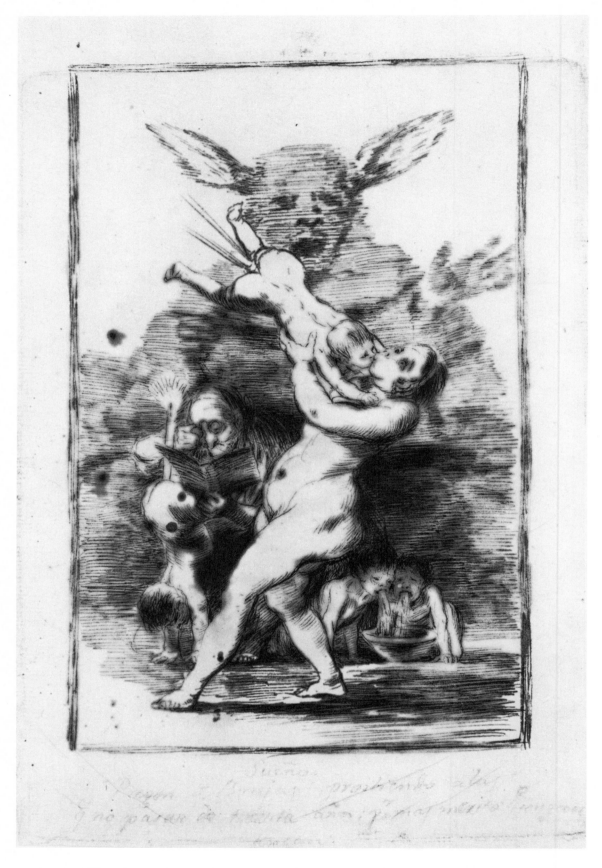

"Dream. Witches' proclamation excluding women under thirty no matter how deserving." Drawing for a *Caprichos*-related subject (no print exists). 1797–8. Pen, sepia ink. 231×153 mm.

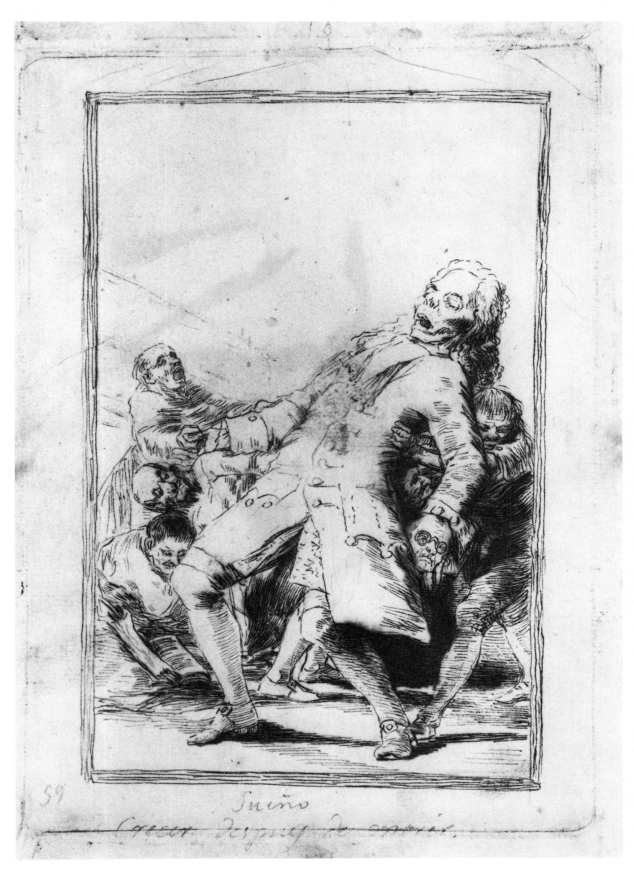

"Dream. Growing after death." Drawing for a *Caprichos*-related subject (no print exists). 1797–8. Pen, sepia ink. 237 × 166 mm.

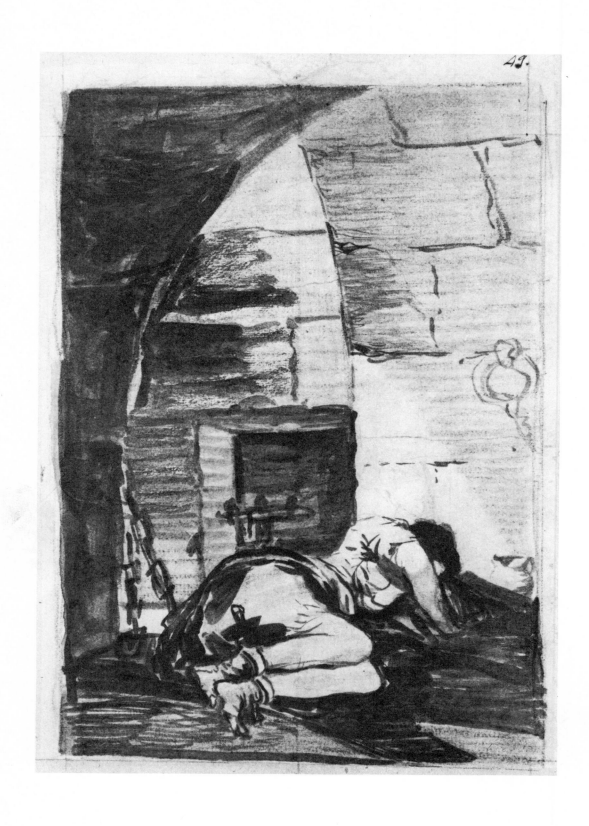

Woman in prison. Drawing for a *Caprichos*-related subject (one proof exists; compare No. 32 of *Los caprichos*). 1797–8. Red wash and sanguine. 200 × 139 mm.

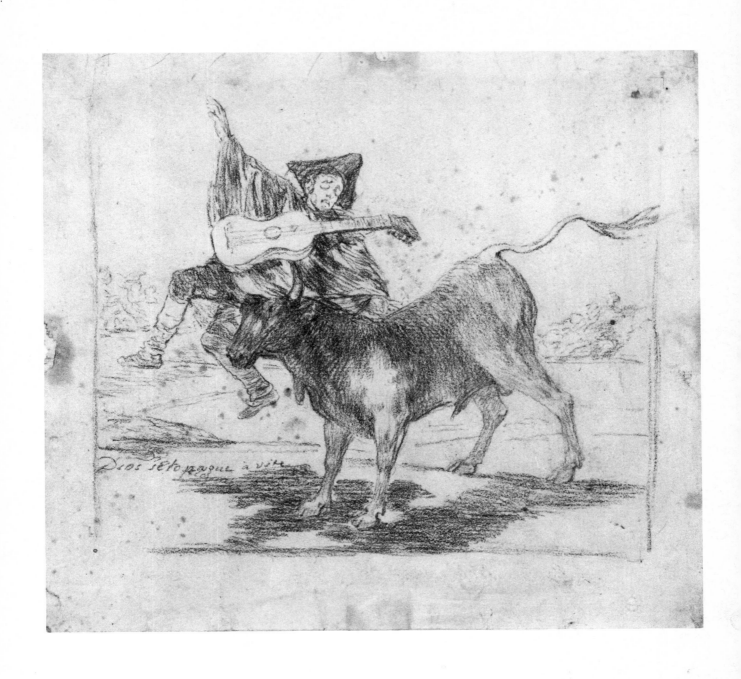

"God reward you!" Preliminary drawing for the print. 1800—04. Sanguine.
172 × 195 mm.

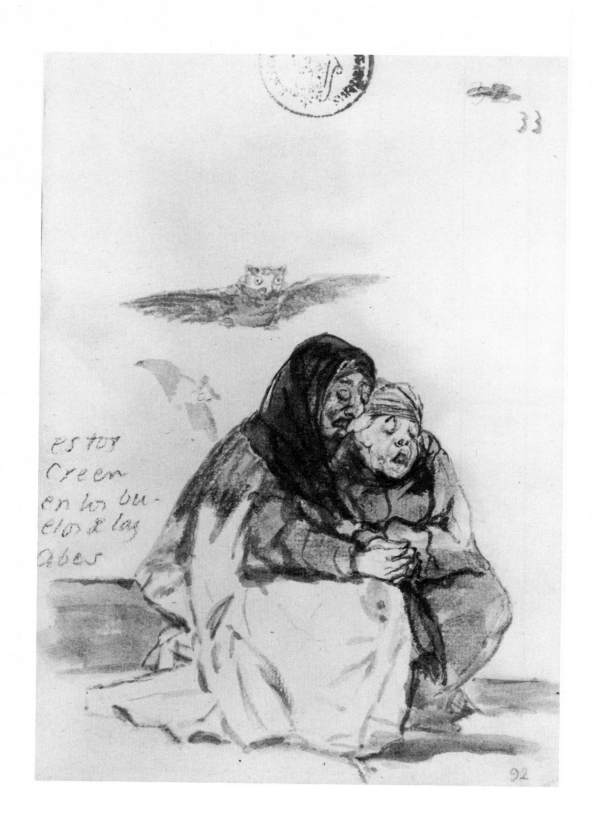

"These people believe in the flights of birds." From Album C ("journal album," maintained ca. 1800–24). 1803–24. Brush, india ink. 205 × 142 mm. (Monks and the owls of reactionary obscurantism.)

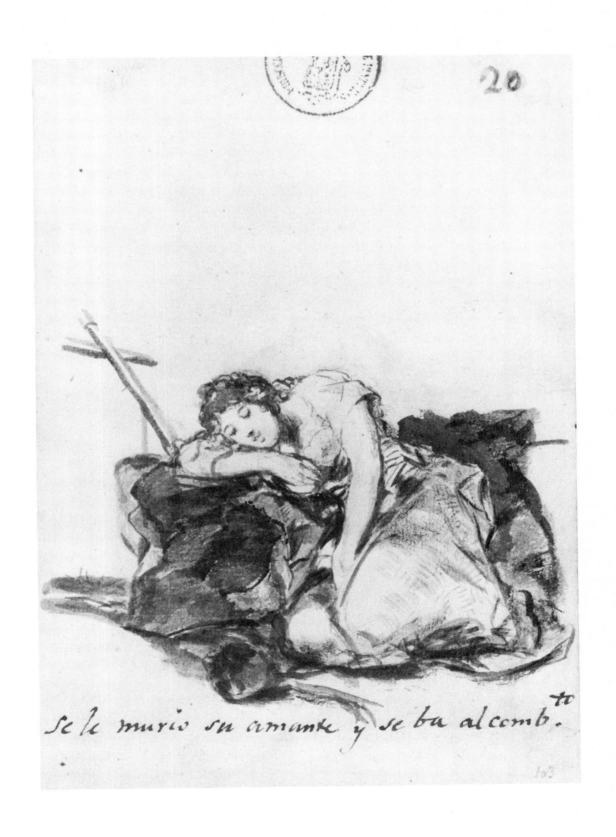

"Her lover died and she is going to the convent." From Album C. 1803–24.
Brush, india ink, with crayon. 205 × 142 mm.

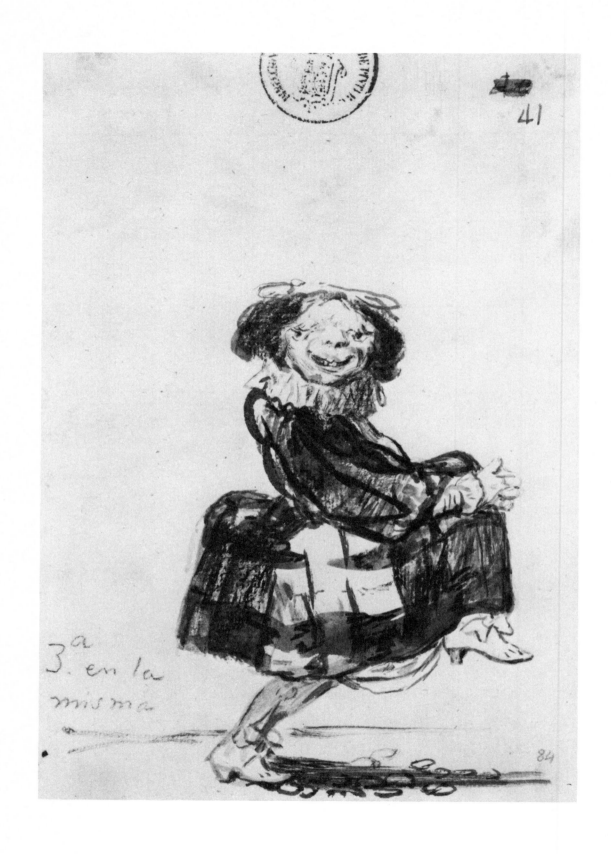

"Third [vision seen] in the same [night]." From Album C; part of a series of
"visions seen in one night" (see also page 26). 1803–24. Crayon. 205 × 141 mm.

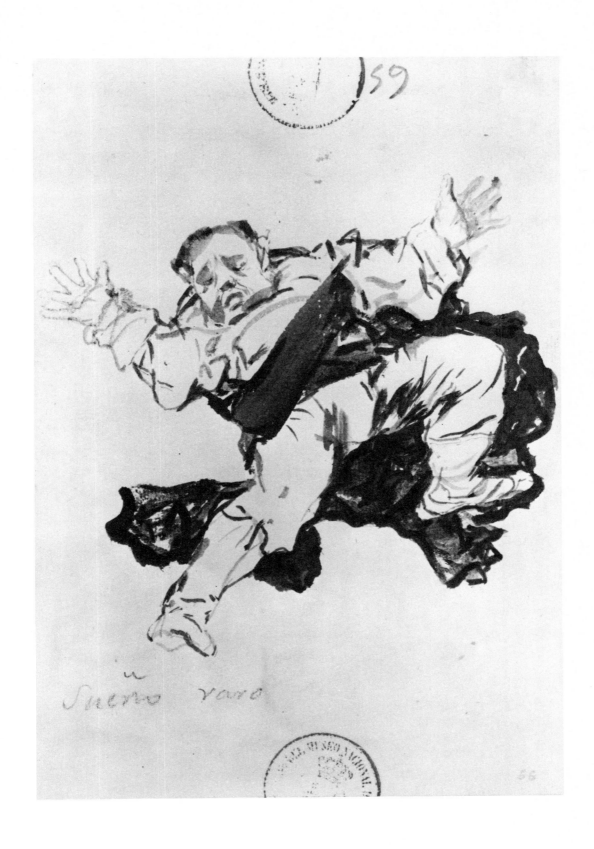

"Unusual dream." From Album C. 1803–24. Brush, sepia, with india ink wash. 205 × 142 mm. (Sleeping monk, floating, twisting out of his habit.)

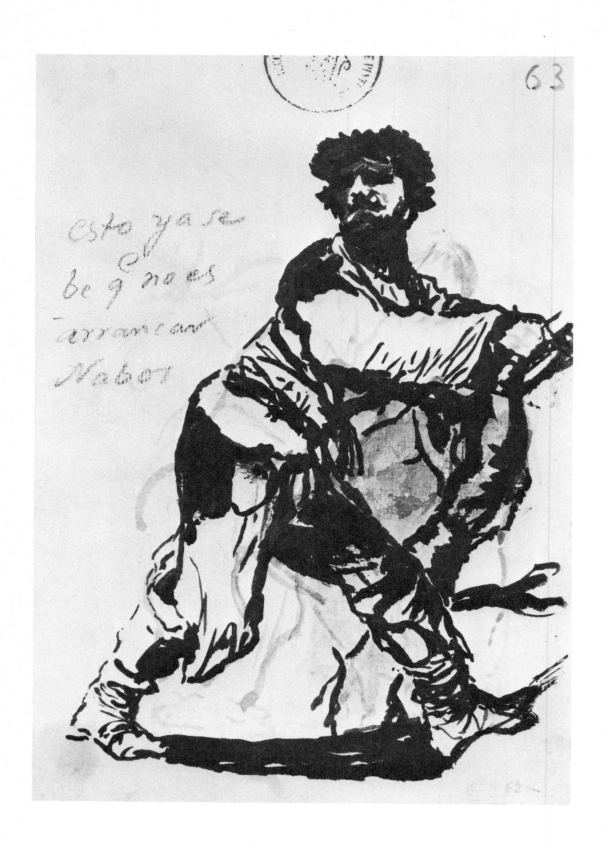

"Now this is obviously not like pulling up turnips." From Album C. 1803–24. Brush, sepia, with india ink wash. 205 × 141 mm. (Peasant pulling up a branch or a small tree.)

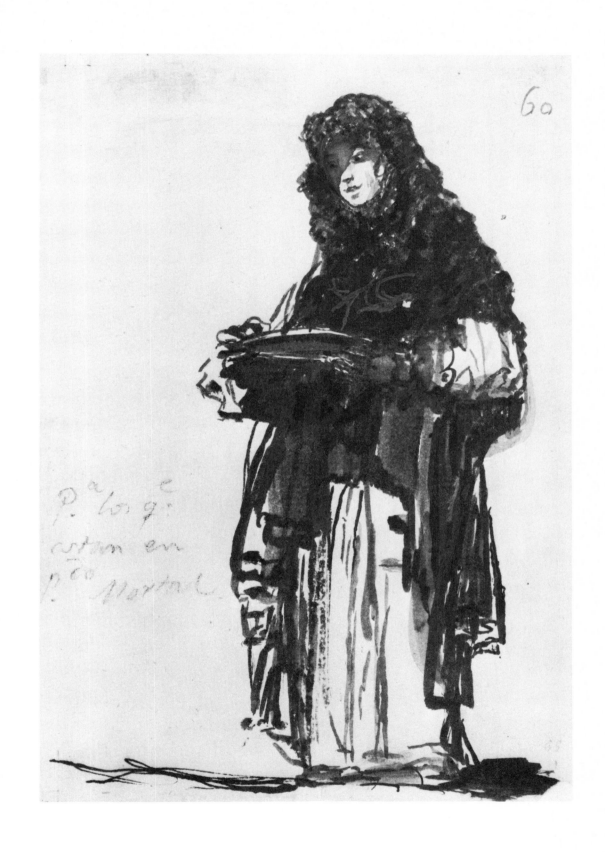

"For those who are in mortal sin." From Album C. 1803–24. Brush, sepia, with pen lines. 205 × 141 mm.

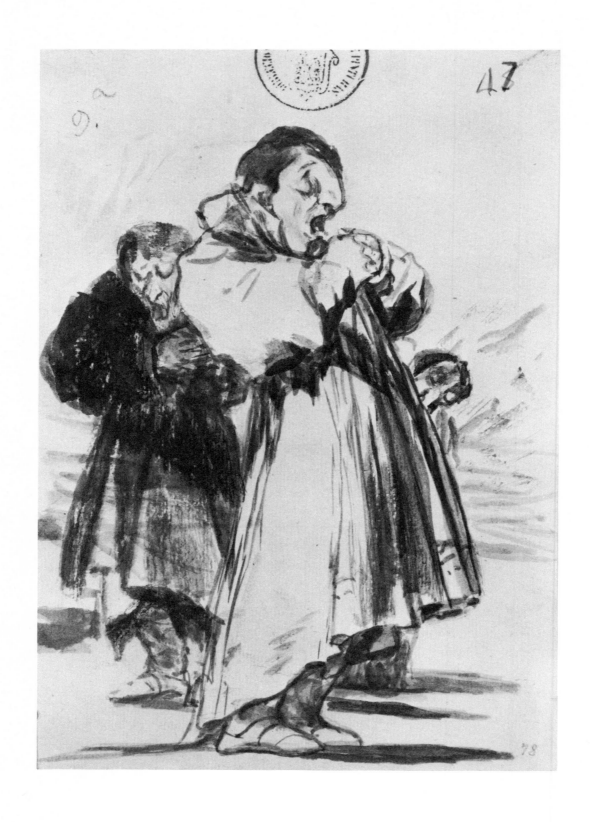

"Ninth [vision seen in the same night]" (compare page 22). From Album C.
1803–24. Brush, india ink. 205 × 140 mm. (Chanting monks.)

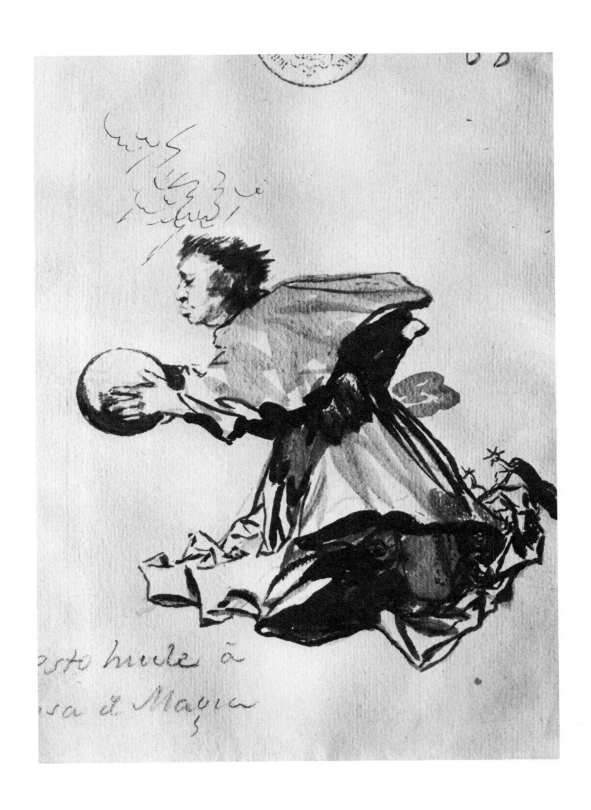

"This reeks of black magic." From Album C. 1808–14. Brush, sepia, with pen lines. 205 × 142 mm. (A pope, probably the politically active Pius VII.)

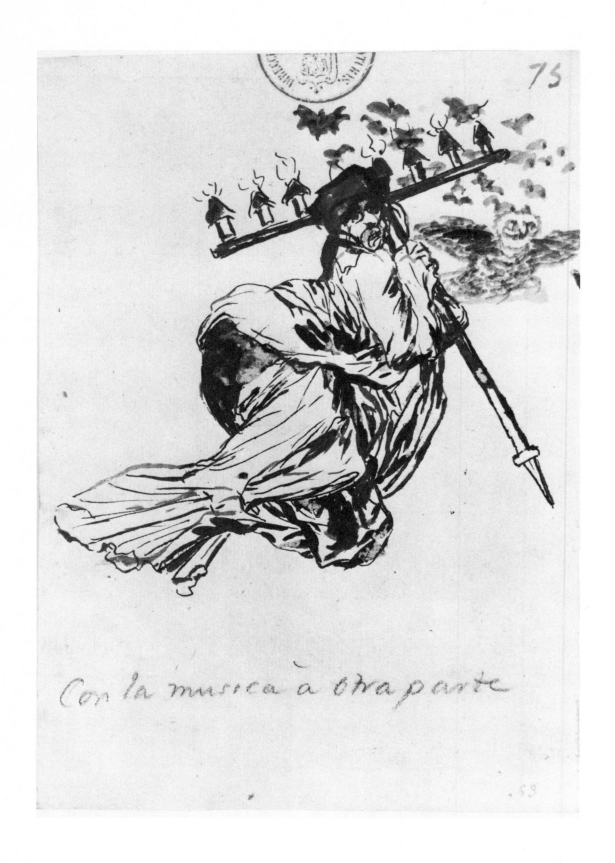

"Beat it!" From Album C. 1812–4. Brush, sepia, with pen and india ink wash. 206 × 142 mm. (Priest with candelabrum; the owls represent ignorance and backwardness.)

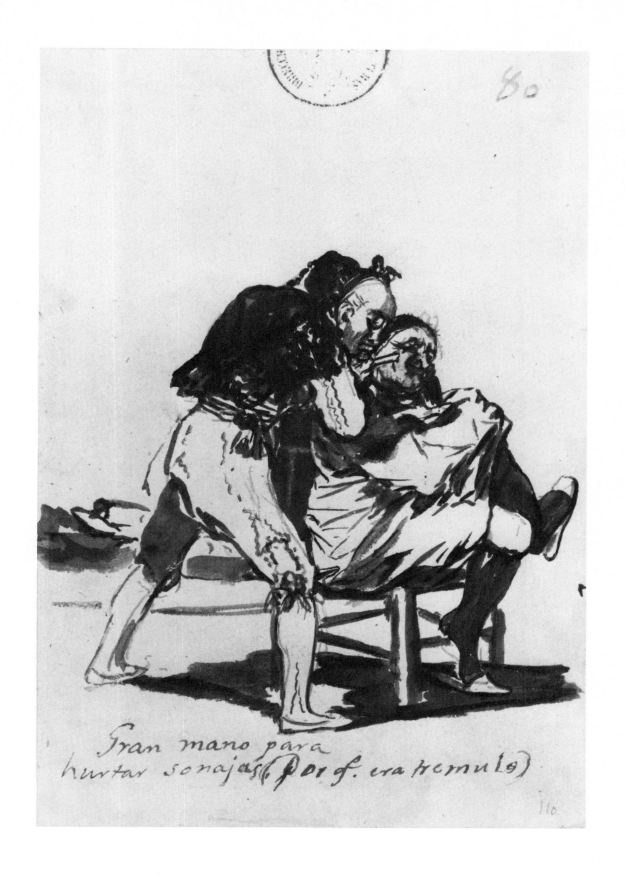

"Great hand at stealing jingle bells (because his hands shook)." From Album C. 1812–24. Brush, sepia. 207 × 143 mm. (Shaky barber shaving apprehensive customer.)

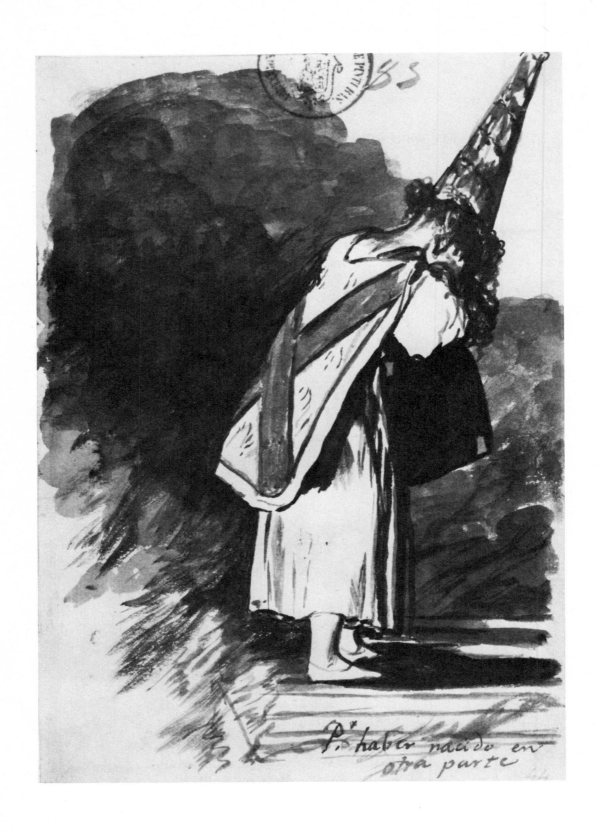

"Because she was born elsewhere." From Album C. 1814–24. Brush, sepia. 205 × 143 mm. (Victim of the Inquisition about to be burned as a heretic.)

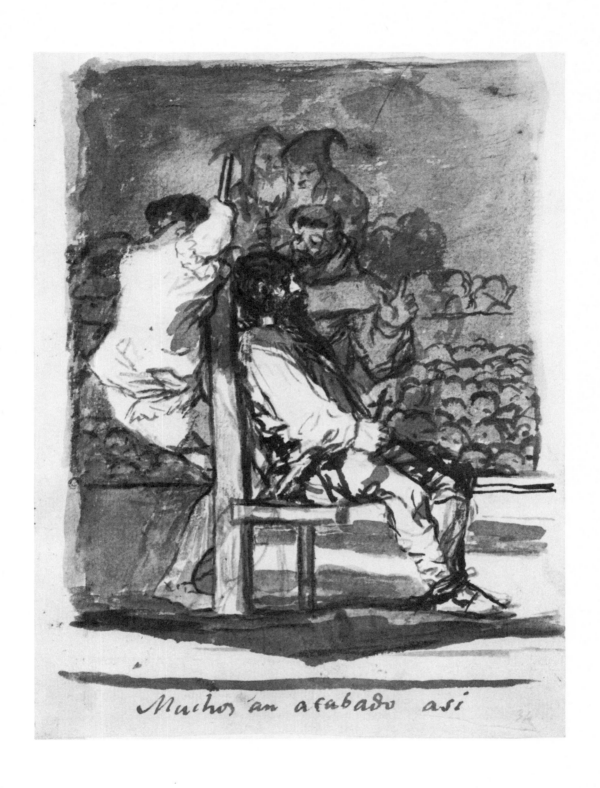

"Many have ended this way." From Album C. 1814–24. Brush, sepia, with india ink wash. 205 × 143 mm. (Man being executed by garroting.)

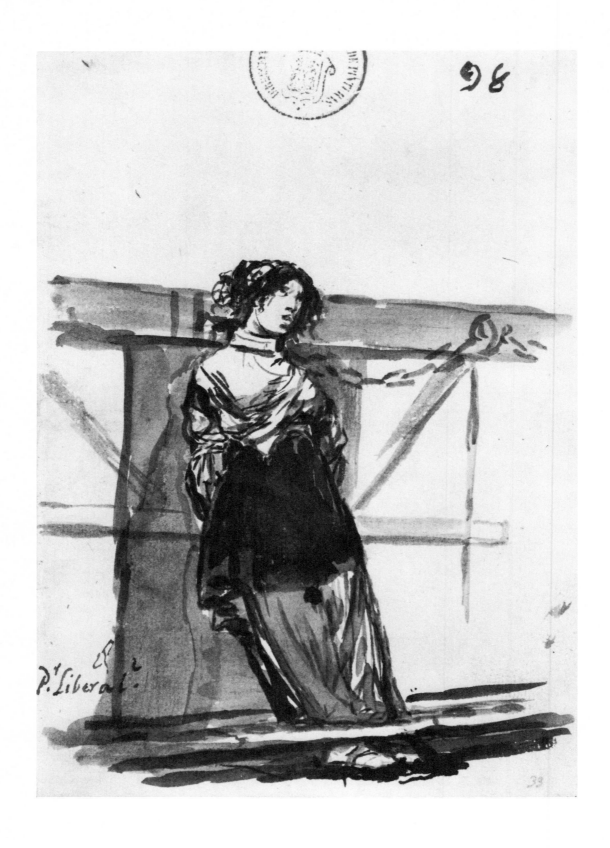

"Because she was a liberal?" From Album C. 1814–24. Brush, sepia, with india ink wash. 205 × 142 mm.

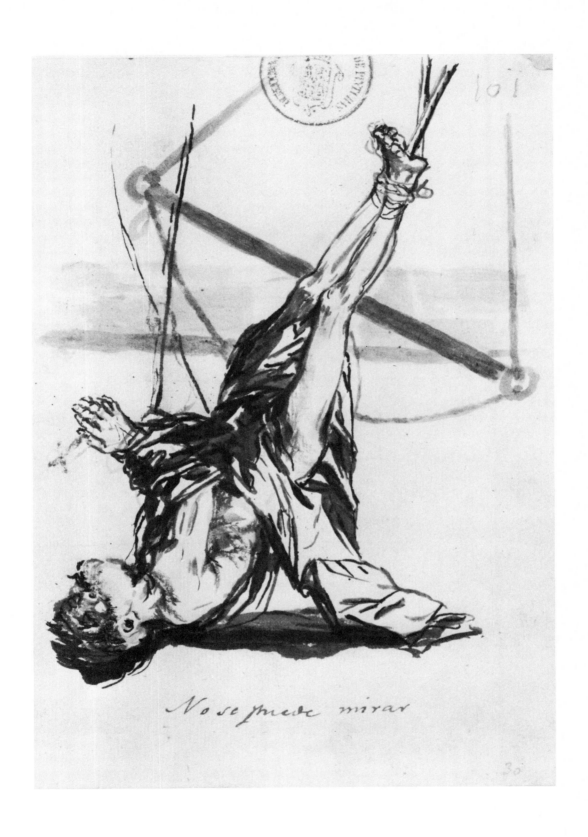

"This is too painful to look at." From Album C. 1814–24. Brush, sepia, with india ink wash. 205 × 142 mm.

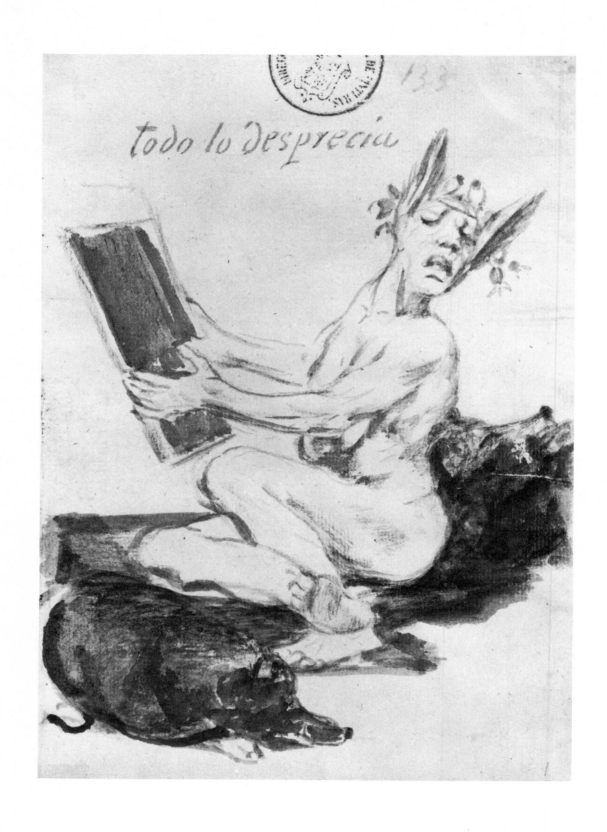

"She has contempt for everything." From Album C. 1820–24. Brush, india ink and sepia. 205 × 146 mm.

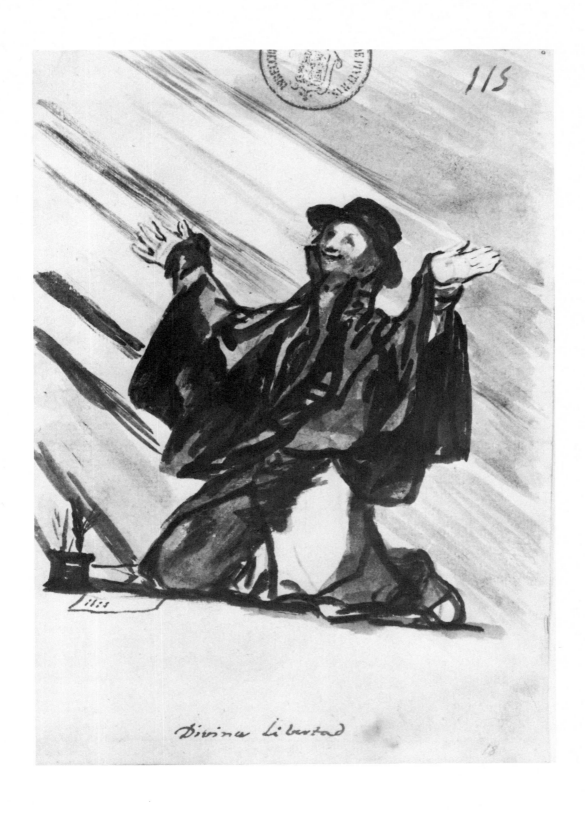

"Divine liberty." From Album C. 1820–24. Brush, sepia, with india ink wash. 205 × 144 mm. (An author grateful for the liberalization of Spanish politics after Riego's revolt.)

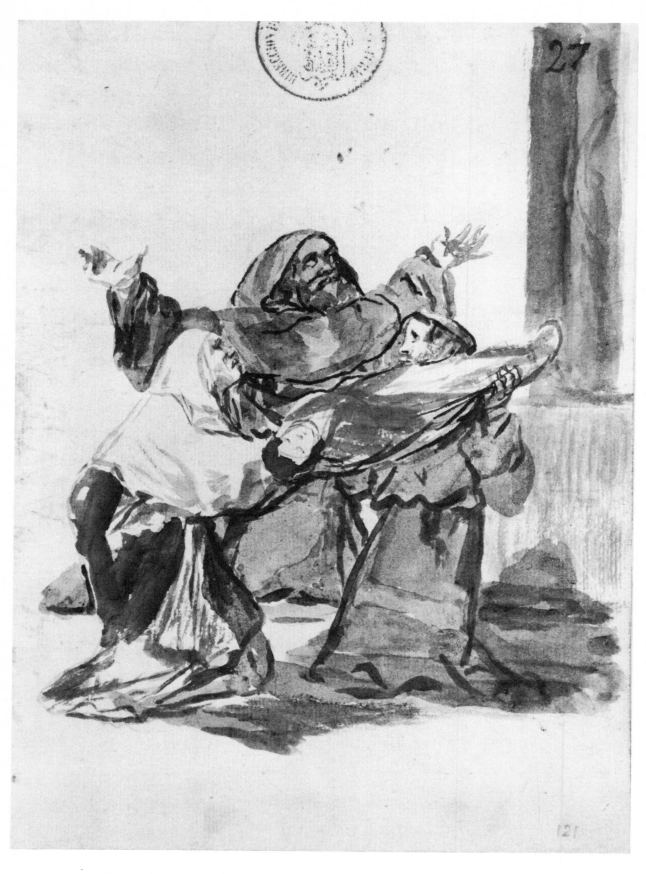

An exorcism. From Album F (maintained 1812–23). 1812–23. Brush, sepia, with india ink wash. 205 × 147 mm. (Peasant mother bringing her sick daughter to a monastery to be cured.)

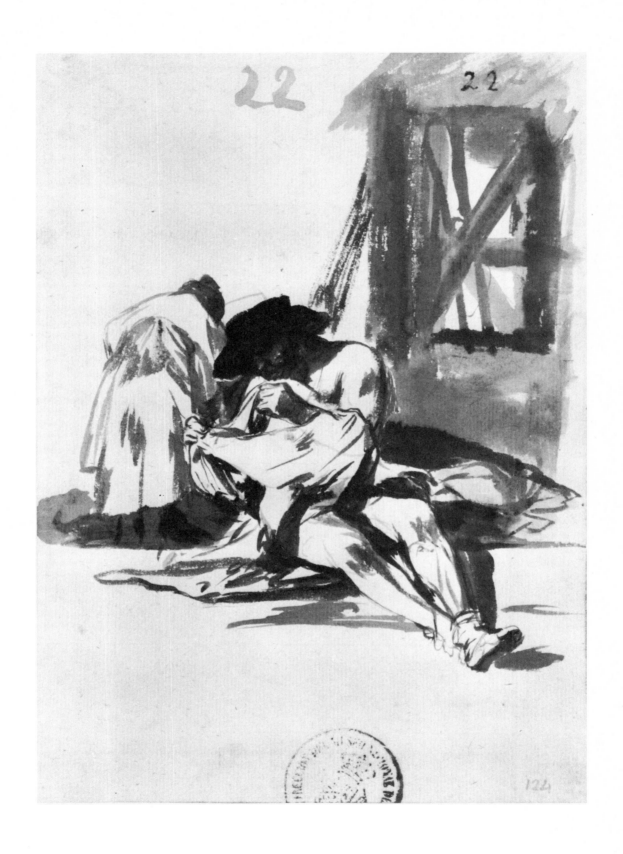

Impoverished rural household. From Album F. 1812–3. Brush, sepia. 205 × 142 mm. (Probably a reminiscence of the famine winter of 1811–2, also commemorated in *The Disasters of War*.)

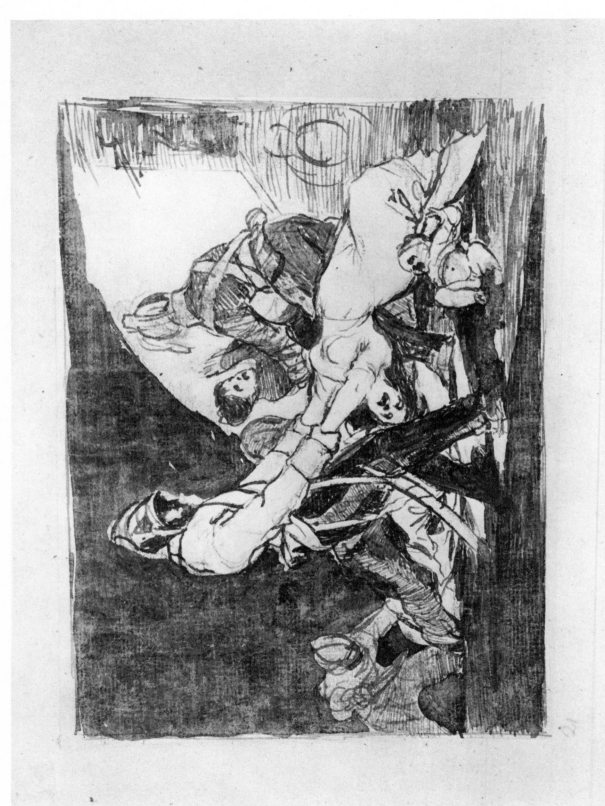

Napoleonic soldiers mistreating Spanish women during the Peninsular War of 1808–14. Preliminary drawing (reversed) for No. 11 of the print series *Los desastres de la guerra* (The Disasters of [the] War). 1810–5. Pen, with sepia wash and sanguine. 134 × 186 mm.

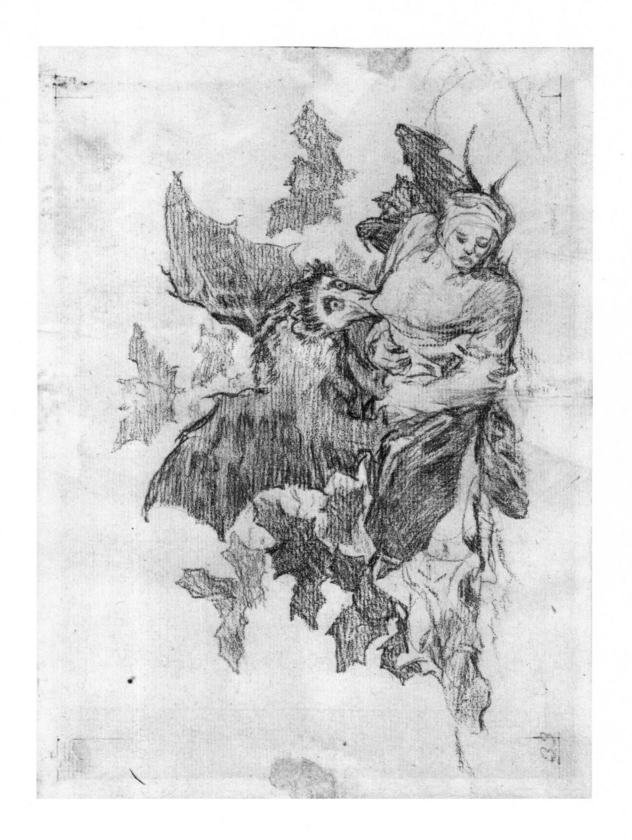

Bat-like monster suckling woman. Preliminary drawing for No. 72 of *The Disasters of War*. 1815–20. Sanguine. 146 × 208 mm. (Reactionary elements rescinding the political gains made by the Spanish people.)

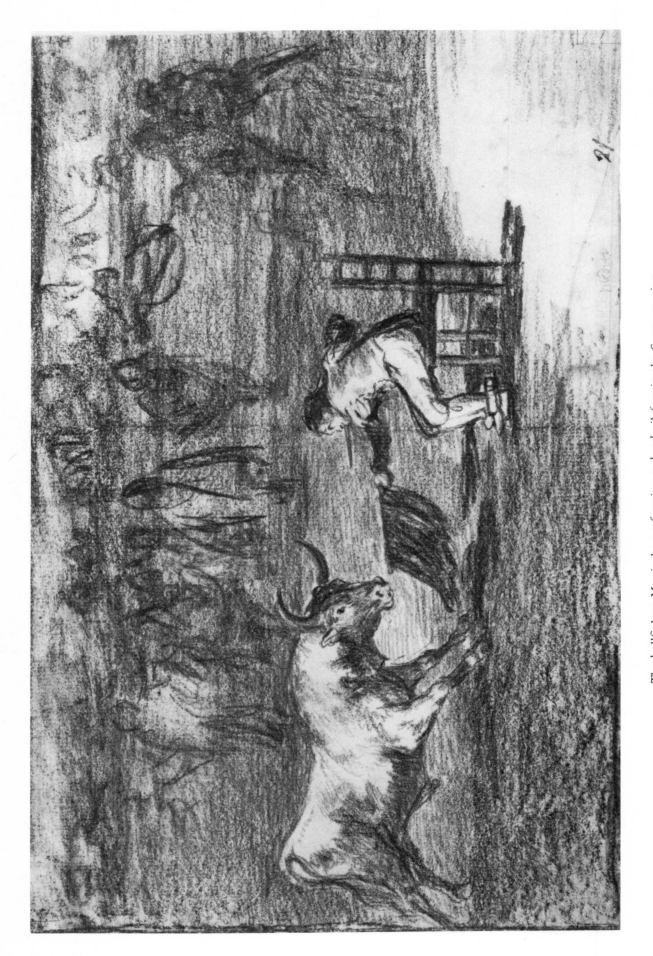

The bullfighter Martincho performing a daredevil feat in the Saragossa ring. Preliminary drawing for a separate print on the same subject as No. 18 of the print series *La tauromaquia* (The Art of Bullfighting), published in 1816. 1815–6. Sanguine. 182 × 296 mm.

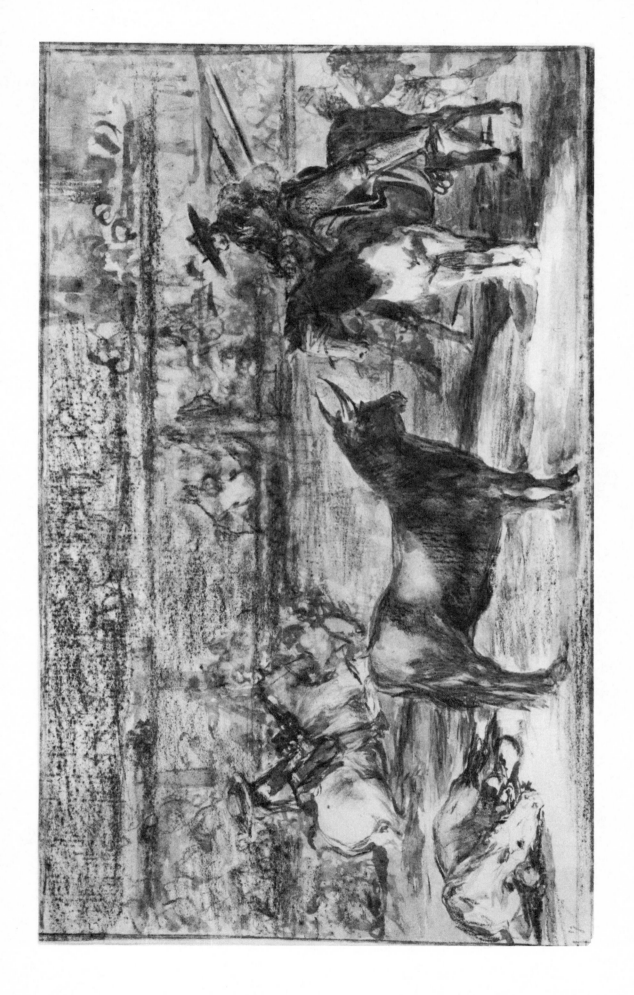

The famous picador Fernando del Toro. Preliminary drawing for No. 27 of *La tauromaquia*. 1815–6. Sanguine, with red wash. 187 × 317 mm.

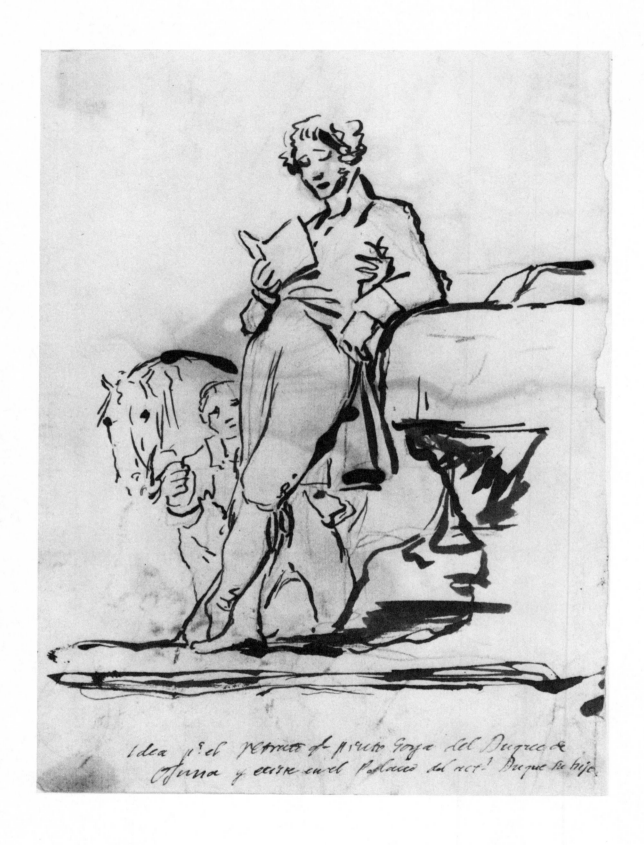

The tenth Duke of Osuna. Preliminary drawing for the painting now in the Musée Bonnat, Bayonne (France). 1816. Brush, sepia, with some pencil. 204 × 151 mm. (Goya's son Javier was the model for this drawing; the identifying inscription is not by Goya but by a nineteenth-century collector.)

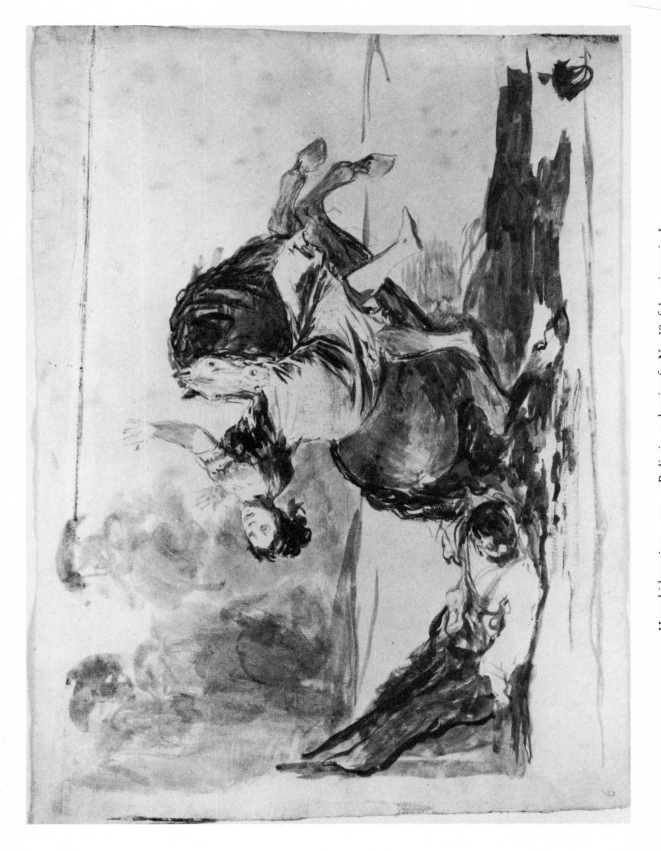

Horse kidnapping a woman. Preliminary drawing for No. 10 of the print series *Los disparates* (Follies), also called *Los proverbios* (The Proverbs). 1815–24. Red wash. 247 × 346 mm.

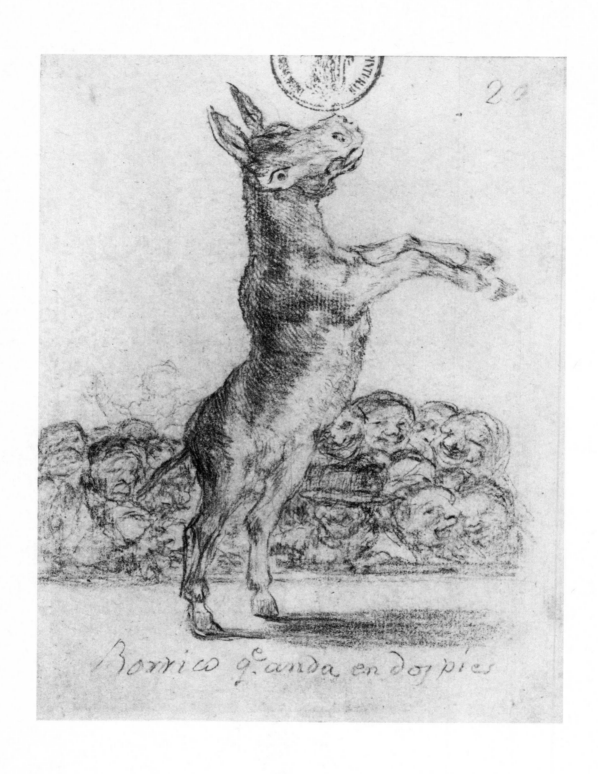

"Donkey walking on two legs." From Album G, dating from the years in France. 1824–8. Charcoal. 191 × 147 mm. (One of a group of circus or street-fair scenes.)

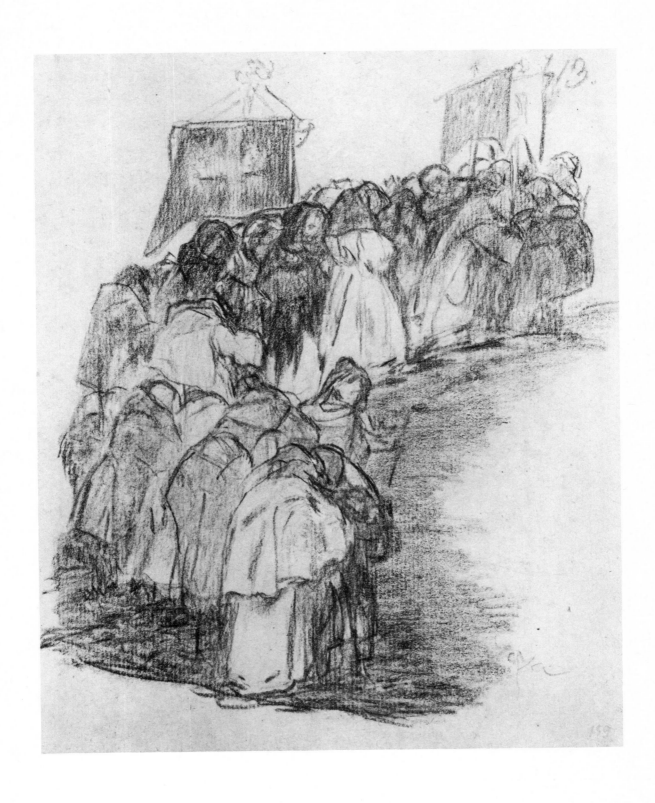

Procession of friars. From Album H, dating from the years in France. 1824–8.
Charcoal. 191 × 155 mm.

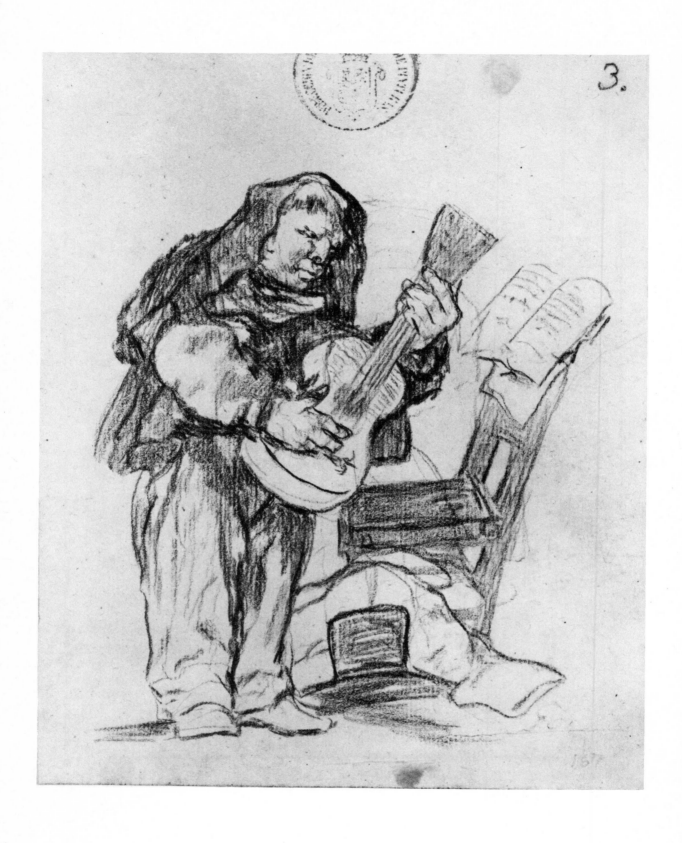

Friar playing the guitar. From Album H. 1824–8. Charcoal. 191 × 155 mm. (At the foot of the chair is a pile of everyday lay clothing.)